101 MOMENTS OF JOY AND INSPIRATION

LANTERN

an imprint of
PENGUIN BOOKS

Meredith Gaston

FELLOW ADVENTURERS,

This little book comes to you with much love and warmest wishes - filled with words of inspiration and joy, and brimming with wise and gentle moments to enrich and brighten your days.

A hundred and one times over, as I sought to bring these words to life with drawings, I was given a new chance to focus on the way our thoughts shape our worlds, and to cultivate the power of joy in my daily life. I hope that these life-affirming pages will be as much a pleasure to explore as they have been for me to create.

I have found in the process of creating this book that my life has become immensely more joyful, harmonious and fulfilling in every way. Stepping out of the fast lane and taking time to truly enjoy the magic and beauty that life has to offer, in a spirit of gratefulness and joy, is true inspiration for the soul.

An inspired life is a life lived to the full.
I hope that these words encourage you to
reach out and take hold of the life you
dream of – remembering that we only live
once and that life is made to be experienced
in all its beauty, complexity, simplicity
and splendour.

There is nothing more wonderful than
loving the life you live, and letting
life love you right back.

I thank my family and friends for
enriching my world with their support
and tenderness. I thank you too, reader,
for taking the time to invite these
moments into your life, and wish you
every joy in watching your life flourish
and transform.

With love,
Meredith

SET YOUR COURSE
BY THE STARS,
NOT BY THE LIGHTS
OF EVERY PASSING
SHIP.

Omar Bradley

BE NOT FORGETFUL
TO ENTERTAIN
STRANGERS, FOR
THEREBY SOME
HAVE ENTERTAINED
ANGELS UNAWARES.

Hebrews 13.2

IMAGINATION
IS MORE
IMPORTANT
THAN KNOWLEDGE.

Albert Einstein

AND THE DAY
CAME WHEN THE
RISK IT TOOK TO
REMAIN TIGHT INSIDE
THE BUD WAS MORE
PAINFUL THAN THE
RISK IT TOOK TO BLOSSOM.

Anais Nin

THE BUTTERFLY
COUNTS NOT
MONTHS BUT
MOMENTS,
AND HAS TIME
ENOUGH.

Rabindranath Tagore

EXPECT
WONDERFUL
THINGS
TO
HAPPEN.

AT BIRTH WE BRING
NOTHING WITH US

AT DEATH WE TAKE NOTHING AWAY.

Chinese proverb

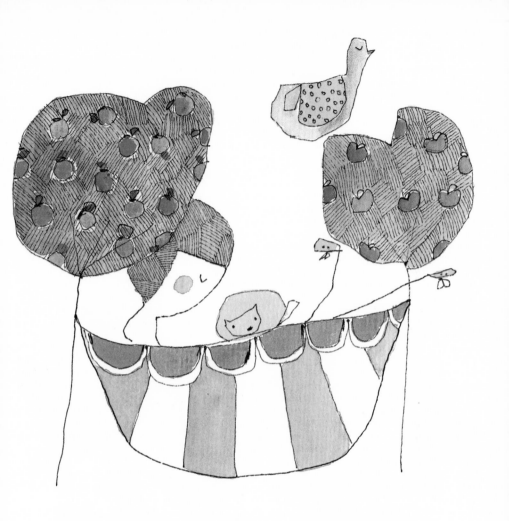

Doing nothing is better than being busy doing nothing.

Lao Tzu

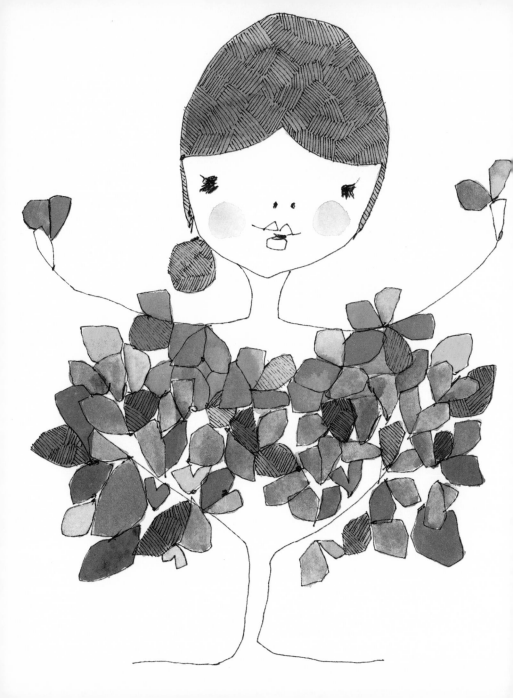

EVERYONE IS THE AGE OF THEIR HEART.

Guatemalan proverb

HAPPINESS IS A JOURNEY, NOT A DESTINATION.

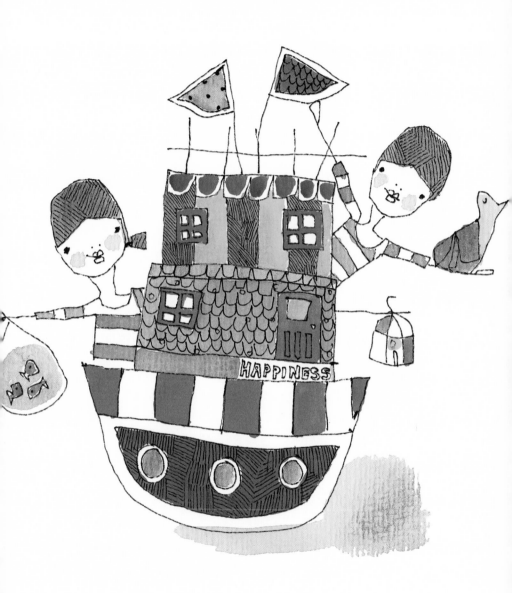

EAT HEALTHILY,
SLEEP WELL,
BREATHE DEEPLY,
MOVE HARMONIOUSLY.

John-Pierre Barral

WE ARE ALWAYS GETTING READY TO LIVE BUT NEVER LIVING.

Ralph Waldo Emerson

When you do things
from your **soul**, you
feel a river moving
in you, a **joy.**

Rumi

THE GOAL IS
NOT TO SAIL
THE BOAT, BUT
RATHER TO HELP
THE BOAT SAIL
HERSELF.

John Roysmaniere

TAKE REST; A FIELD THAT
HAS RESTED GIVES A
BOUNTIFUL CROP. Ovid

LET THE
BEAUTY OF
WHAT YOU LOVE
BE WHAT YOU
DO.

RUMI

NOBODY CAN GO
BACK AND START
A NEW BEGINNING,
BUT ANYONE CAN
START TODAY
AND MAKE A NEW
ENDING.

Maria Robinson

There is only one
person who could ever
make you happy,
and that person is you.

David Burns

Family and friends

Health

Career

Rest and relaxation

Hobbies and passions

Personal development

THE WORLD IS ROUND, AND THE PLACE WHICH MAY SEEM LIKE THE END . IS THE BEGINNING.

WE SHOULD
CONSIDER EVERY
DAY LOST ON
WHICH WE HAVE
NOT DANCED
AT LEAST ONCE.

Friedrich Nietzsche

AS YOU WALK,
EAT AND TRAVEL,
BE WHERE YOU ARE.
OTHERWISE YOU
WILL MISS MOST OF
YOUR LIFE.

Buddha

HELP ONE PERSON ALONG THEIR PATH, AND YOU HAVE DONE WELL IN THE WORLD.

THERE ARE NO MISTAKES

ONLY LESSONS.
chinese proverb

THE JOURNEY OF A THOUSAND MILES BEGINS WITH THE FIRST STEP.

BE GRATEFUL FOR
WHOEVER COMES,
BECAUSE EACH
HAS BEEN SENT
AS A GUIDE FROM
BEYOND.

Rumi

SILENCE IS THE SLEEP THAT NOURISHES WISDOM.

Francis Bacon

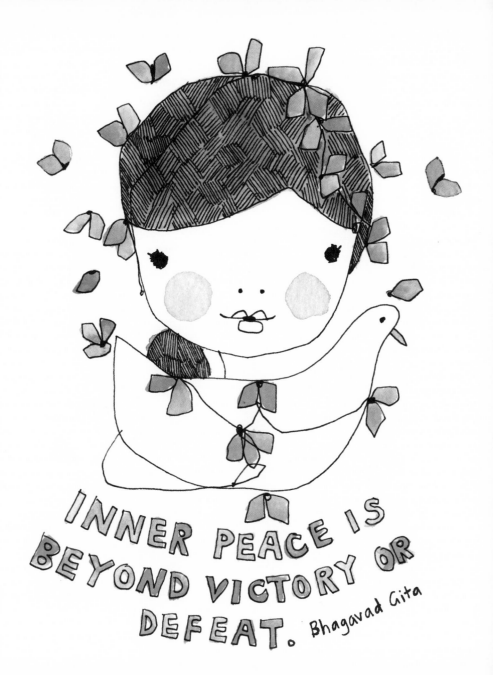

INNER PEACE IS BEYOND VICTORY OR DEFEAT. Bhagavad Gita

TENSION IS WHO YOU THINK YOU SHOULD BE, RELAXATION IS WHO YOU ARE

Chinese proverb

TIME IS BUT THE STREAM
I GO A-FISHING IN.

Henry David Thoreau

MAY THE WIND BE ALWAYS AT YOUR BACK

AND MAY THE
SUNSHINE BE WARM
UPON YOUR FACE.

Irish Proverb

THERE MUST BE QUITE A LOT OF THINGS THAT A HOT BATH CAN'T CURE, BUT I DON'T KNOW MANY OF THEM.

Esther Greenwood in
'The Bell Jar', Sylvia Plath

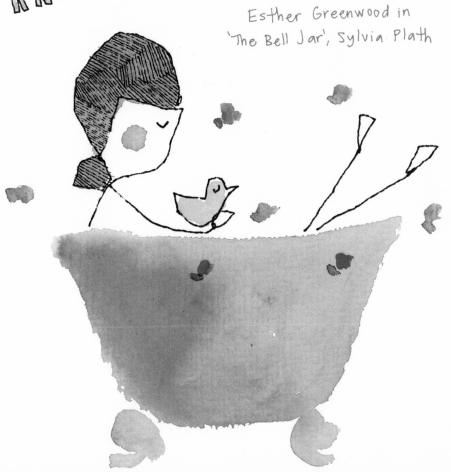

FRIENDSHIP IS A SHELTERING TREE.

Samuel Taylor
Coleridge

Monday

Tuesday

Wednesday

Thursday

Friday

Saturday

Sunday

Special
occasions

Accessorising

OH, NEVER MIND FASHION. WHEN ONE HAS A STYLE OF ONE'S OWN, IT IS ALWAYS TWENTY TIMES BETTER.

Margaret Oliphant

OUR TRUEST
LIFE IS WHEN
WE ARE
IN DREAMS
AWAKE.

Henry David Thoreau

LIVE EVERY DAY

LAUGH, LOVE, AND ENJOY!

WHAT IS NOT STARTED TODAY IS NEVER FINISHED TOMORROW.

Johann Wolfgang Von Goethe

Time is not measured by the years that
you live but by the **deeds** that you do and
the **joy** that you give.

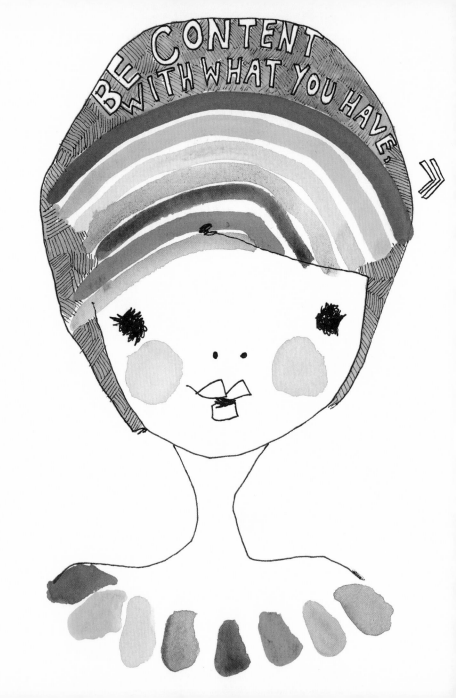

REJOICE IN THE
WAY THINGS ARE.
WHEN YOU REALISE
THERE IS NOTHING
LACKING, THE WHOLE
WORLD BELONGS TO YOU.

Lao Tzu

HOW BEAUTIFUL IT IS TO DO NOTHING, AND THEN TO REST AFTERWARD.

Spanish proverb

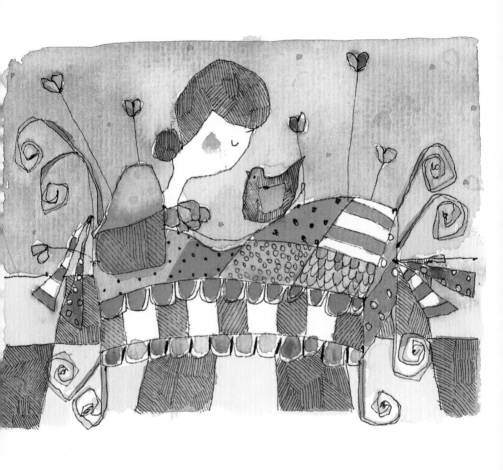

LEARN FROM YESTERDAY, LIVE FOR TODAY, HOPE FOR TOMORROW.

Albert Einstein

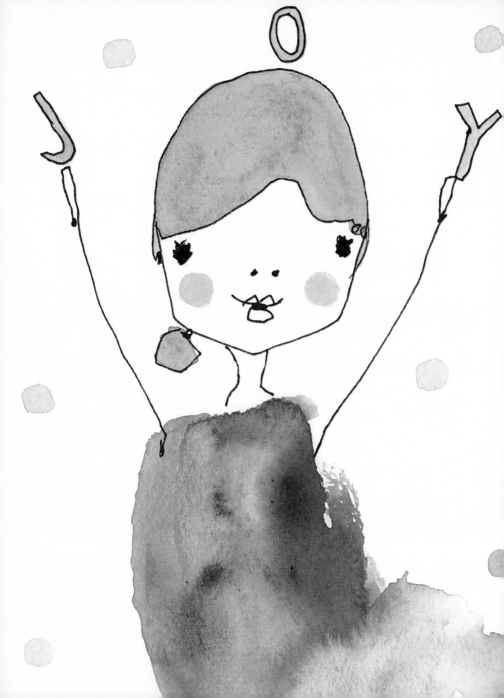

When I let go of
what I am,
I become what I might
be.

Lao Tzu

LIFE IS NOT ABOUT FINDING OURSELVES, IT IS ABOUT CREATING OURSELVES.

George Bernard Shaw

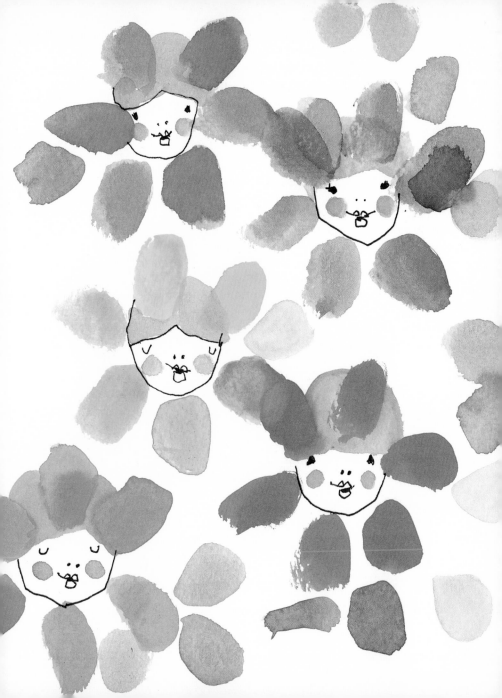

THERE IS NO
CHARM EQUAL
TO TENDERNESS
OF HEART.

Jane Austen,
'Emma'

WHEREVER YOU GO, GO WITH ALL YOUR HEART.

Confucius

COURAGE IS KNOWING WHAT NOT TO FEAR.

Plato

NOTHING IS
IMPOSSIBLE

TO A WILLING
HEART.

Too often we underestimate
the power of a touch, a smile,
a kind word, a listening ear,
an honest compliment, or the
smallest act of caring, all of
which have the potential to
turn a life around.

Leo Buscaglia

FALL DOWN
SEVEN TIMES,

GET UP EIGHT!

Chinese proverb

I WANT TO SING
LIKE THE BIRDS
SING, NOT
WORRYING ABOUT
WHO HEARS OR
WHAT THEY THINK!

Rumi

CLOUDS COME
FLOATING INTO MY
LIFE,

NO LONGER TO CARRY
RAIN OR USHER STORM,
BUT TO ADD COLOUR
TO MY SUNSET SKY.

Rabindranath Tagore

YOU MAY THINK THAT
THE GRASS IS GREENER
ON THE OTHER SIDE

BUT IF YOU
TAKE THE TIME
TO WATER YOUR
OWN GRASS
IT WOULD BE JUST
AS GREEN.

THOSE WHO WISH TO SING ALWAYS FIND A SONG.

swedish proverb

DON'T ASK
FOR AN EASIER
LIFE, ASK TO
BE A STRONGER
PERSON.

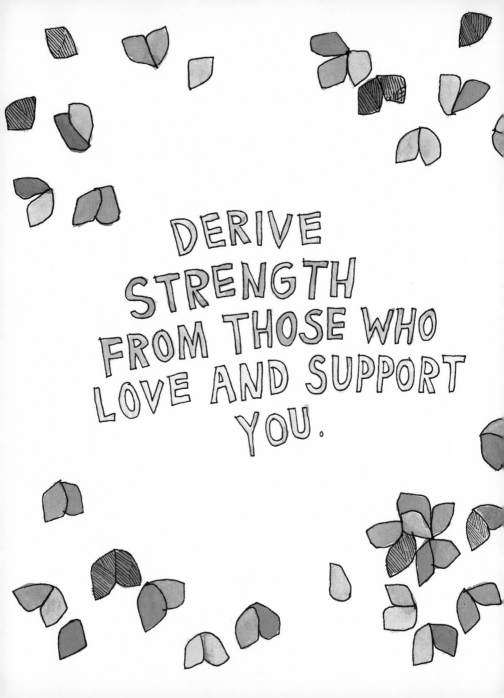

LIFE MUST BE LIVED AS PLAY.

p l a t o

I SHOULD
SUGAR
AND PRESERVE
MY DAYS
LIKE FRUIT.

Sylvia Plath

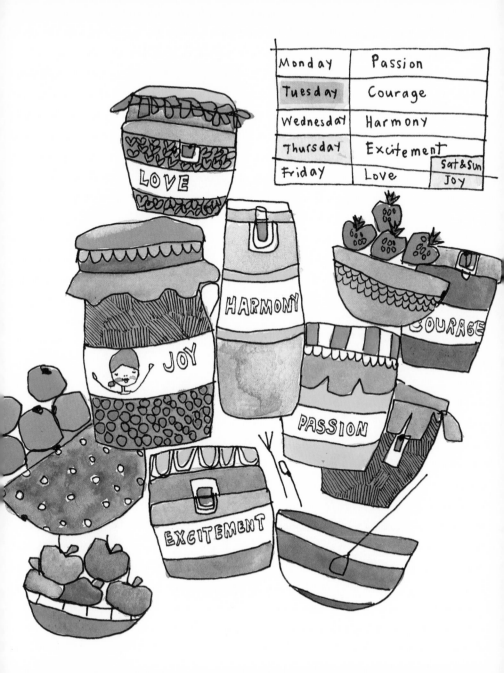

Monday	Passion
Tuesday	Courage
Wednesday	Harmony
Thursday	Excitement
Friday	Love
Sat&Sun	Joy

LOVE

JOY

HARMONY

COURAGE

PASSION

EXCITEMENT

KEEP YOUR FACE
ALWAYS TOWARD
THE SUNSHINE AND
SHADOWS WILL FALL
BEHIND YOU.

Walt Whitman

COME FORTH INTO THE LIGHT OF THINGS, LET NATURE BE YOUR TEACHER.

William Wordswort

SOMETIMES YOU HAVE TO BE YOUR OWN HERO.

The secret to **happiness** is **freedom**... And the secret to freedom is **courage**.

Thucydides

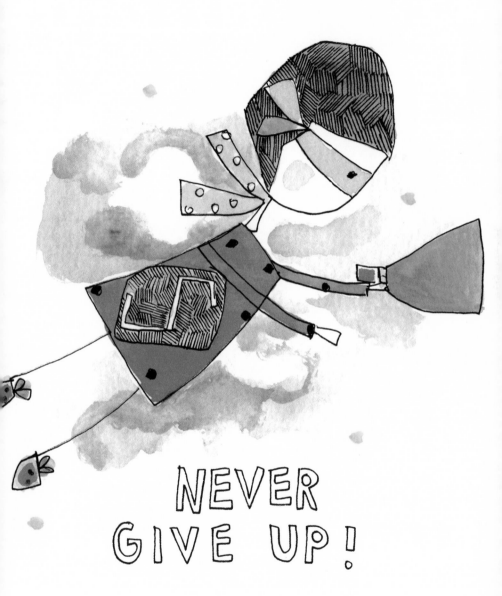

NEVER
GIVE UP!

LIFE IS WHAT
HAPPENS TO US
WHEN WE ARE BUSY
MAKING OTHER PLANS.

SHE IS THE
RICHEST WHO
IS CONTENT
WITH THE
LEAST.

Socrates

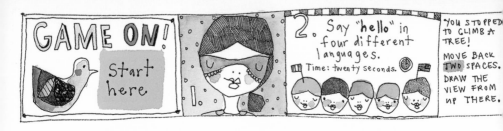
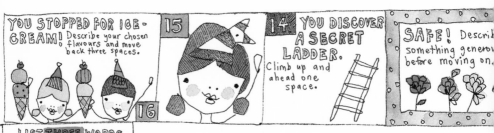

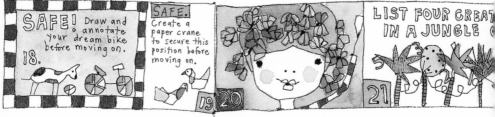

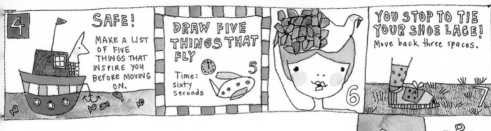

4 SAFE! MAKE A LIST OF FIVE THINGS THAT INSPIRE YOU BEFORE MOVING ON.

DRAW FIVE THINGS THAT FLY
Time: sixty seconds **5**

6

YOU STOP TO TIE YOUR SHOE LACE! Move back three spaces. **7**

THE MIND

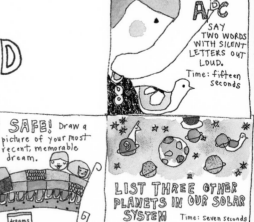

ABC SAY TWO WORDS WITH SILENT LETTERS OUT LOUD. Time: fifteen seconds

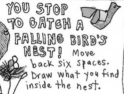

YOU STOP TO CATCH A FALLING BIRD'S NEST! Move back six spaces. Draw what you find inside the nest. **12**

List five other words for BIG! Time: fifteen seconds **11**

10 SAFE! Draw a picture of your most recent, memorable dream. dreams

9 LIST THREE OTHER PLANETS IN OUR SOLAR SYSTEM Time: seven seconds

ESSENCE OF LIFE.

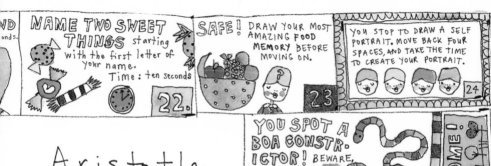

NAME TWO SWEET THINGS starting with the first letter of your name. Time: ten seconds **22.**

SAFE! DRAW YOUR MOST AMAZING FOOD MEMORY BEFORE MOVING ON. **23**

YOU STOP TO DRAW A SELF PORTRAIT. MOVE BACK FOUR SPACES, AND TAKE THE TIME TO CREATE YOUR PORTRAIT. **24**

Aristotle

YOU SPOT A BOA CONSTRICTOR! BEWARE, and move back SIX SPACES. (almost there...) **25**

HOME!

HEALTH IS THE
GREATEST
POSSESSION,
CONTENTMENT THE
GREATEST TREASURE,
CONFIDENCE THE
GREATEST FRIEND.

Lao Tzu

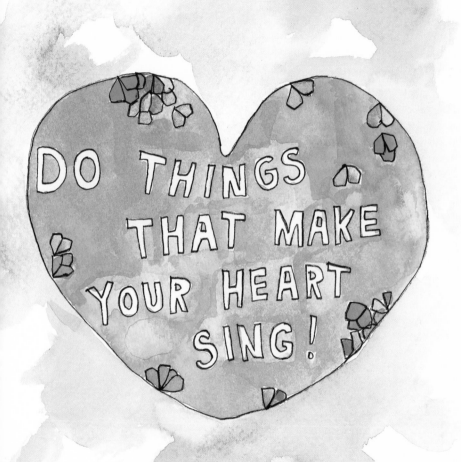

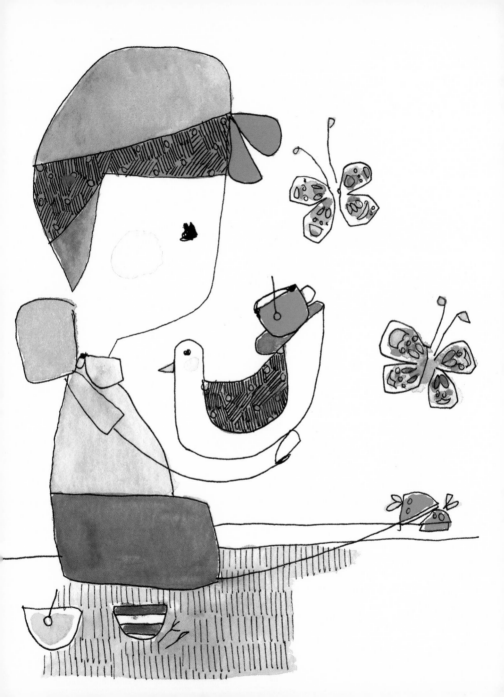

LIVE EACH DAY
TO THE FULL,

ENJOY WHAT LIFE
HAS TO OFFER.

THOUGH WE
TRAVEL THE WORLD
OVER TO FIND THE
BEAUTIFUL,
WE MUST CARRY
IT WITH US OR WE
FIND IT NOT.

Ralph Waldo Emerson

ADOPT THE PACE OF NATURE: HER SECRET IS PATIENCE.

Ralph Waldo Emerson

EACH MORNING WE
ARE BORN AGAIN. WHAT WE
DO TODAY MATTERS MOST.

Buddha

KEEP BUSY, KEEP POSITIVE
KEEP STRONG.

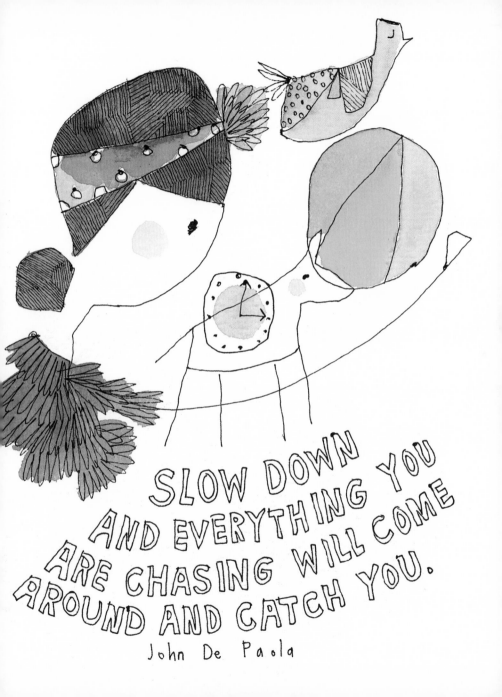

SLOW DOWN AND EVERYTHING YOU ARE CHASING WILL COME AROUND AND CATCH YOU.

John De Paola

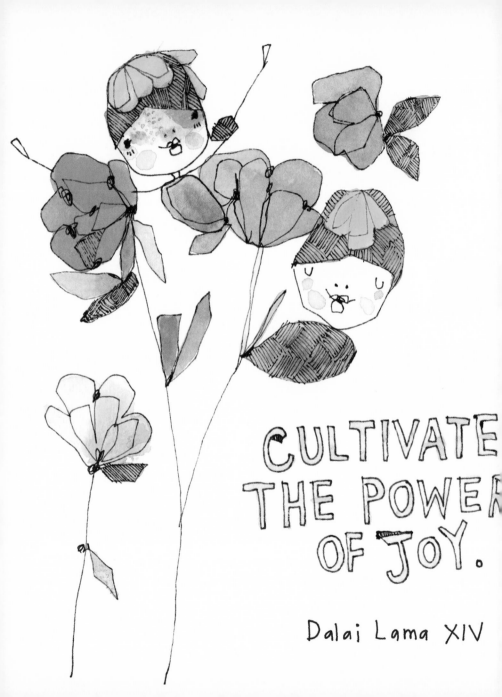

CULTIVATE
THE POWER
OF JOY.

Dalai Lama XIV

I'M NOT AFRAID
OF STORMS, FOR
I'M LEARNING TO
SAIL MY SHIP.

Louisa May Alcott

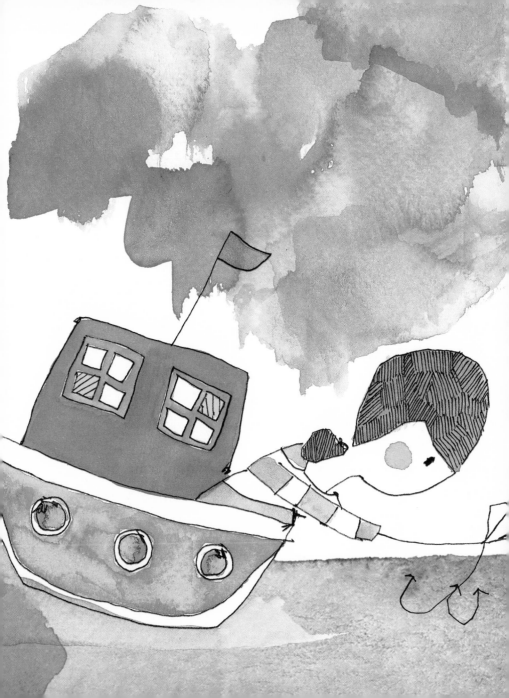

The bond that links
your true family is
not one of blood, but
of respect and joy in
each other's lives.

Richard Bach

PEACE COMES WHEN YOU FORGET FEAR.

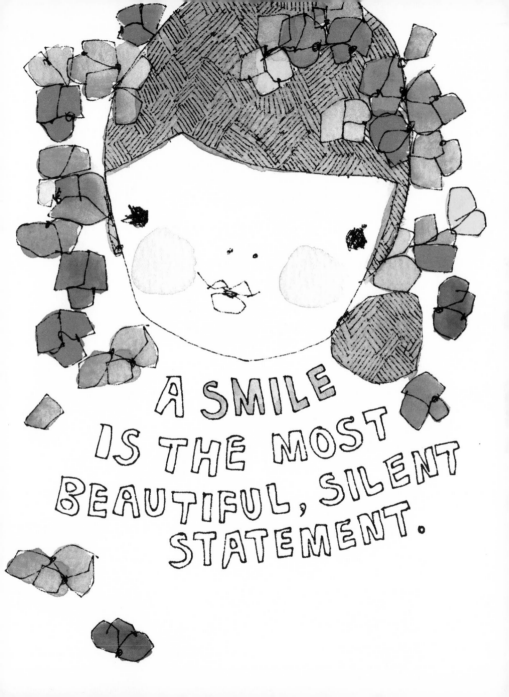

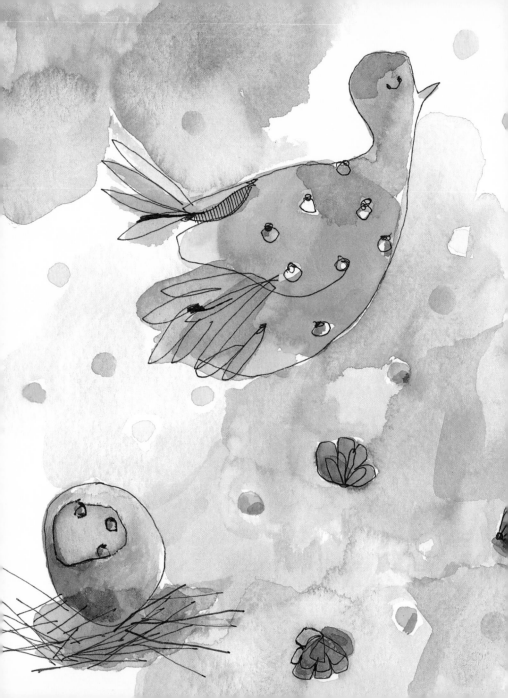

THE SHELL MUST BREAK BEFORE THE BIRD CAN FLY.

Alfred, Lord Tennyson

BE FAITHFUL IN SMALL THINGS,

BECAUSE IT IS IN THEM THAT YOUR STRENGTH LIES.

Mother Teresa

There are **two** ways
to live your life.

One is as though nothing
is a miracle,

the other is as though
everything
is a miracle.

Albert
Einstein

ALL OF OUR DREAMS
CAN COME TRUE,
IF WE HAVE THE COURAGE
TO PURSUE THEM.

Walt Disney

THE TIME TO RELAX IS WHEN YOU DON'T HAVE TIME FOR IT.

Sydney Harris

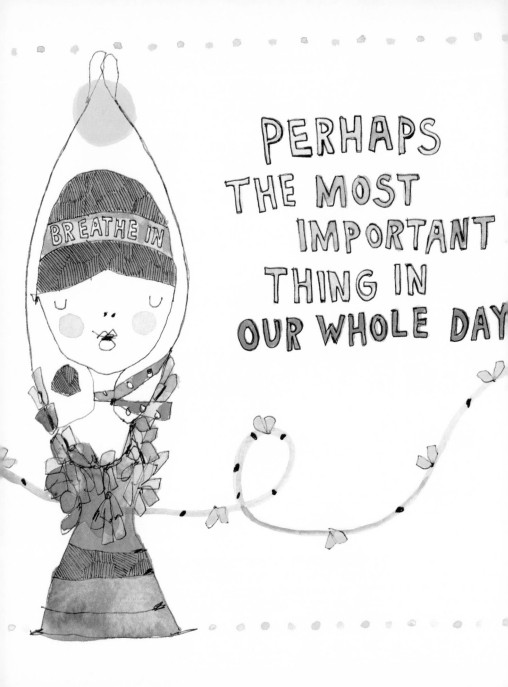

BREATHE IN

PERHAPS THE MOST IMPORTANT THING IN OUR WHOLE DAY

IS THE
REST
WE TAKE
BETWEEN
TWO
DEEP
BREATHS.

BREATHE OUT

Etty
Hillesum

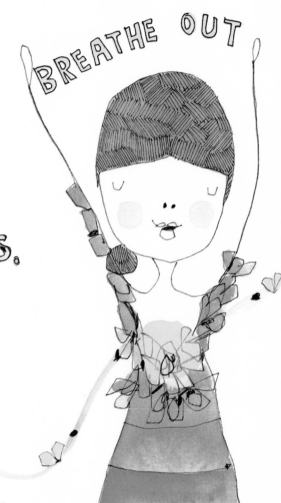

YOUR THOUGHTS CREATE YOUR WORLD.

Lao Tzu

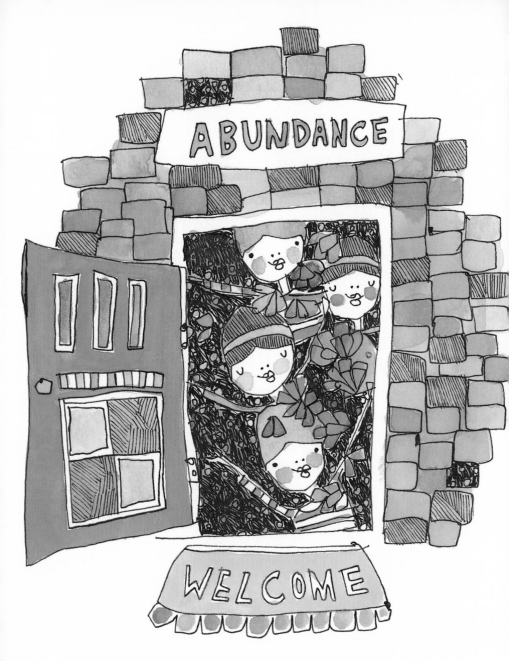

GRATITUDE
IS THE
OPEN DOOR
TO
ABUNDANCE.

Sunshine is delicious,
rain is refreshing,
wind braces us up,
snow is exhilarating.
There is really no such thing
as bad weather,
Only different kinds of
good weather.

John Ruskin

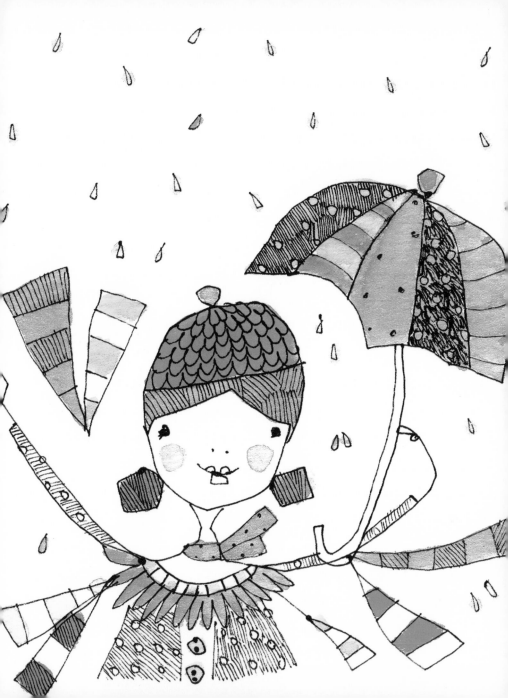

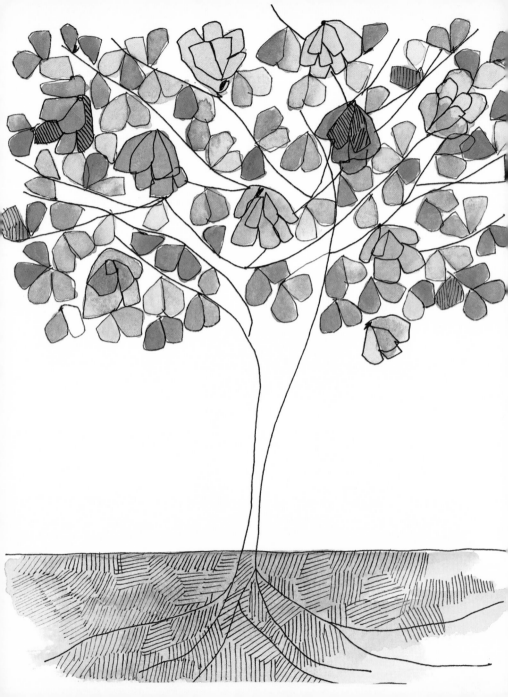

STORMS MAKE TREES TAKE DEEPER ROOTS.

Dolly Parton

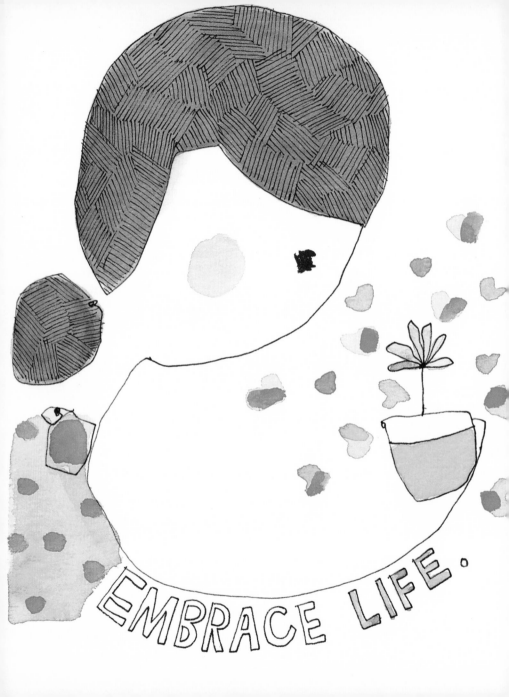

EMBRACE LIFE.

IF A MAN BE
GRACIOUS AND
COURTEOUS TO
STRANGERS, IT
SHOWS HE IS
A CITIZEN OF
THE WORLD.

Francis Bacon

TO LOVE
ONESELF
IS THE
BEGINNING
OF A
LIFELONG
ROMANCE.

Oscar Wilde

SOMETIMES FEAR
AND COURAGE WALK
SIDE BY SIDE.

TODAY YOU ARE
YOU THAT IS TRUER
THAN TRUE, THERE
IS NO ONE ALIVE
WHO IS YOUER THAN
YOU.

Dr Seuss

IT ISN'T WHERE YOU'VE COME FROM, IT'S WHERE YOU'RE GOING THAT COUNTS.

Ella Fitzgerald

AND LIFE WILL LOVE YOU BACK.

Arthur Rubinstein

IT IS NOT THE STRONGEST OF THE SPECIES THAT SURVIVES, NOR THE MOST INTELLIGENT THAT SURVIVES. IT IS THE ONE THAT IS MOST ADAPTABLE TO CHANGE.

Leon C Megginson

BE YOURSELF.
EVERYONE ELSE IS
ALREADY TAKEN.

Oscar Wilde

LET US BE GRATEFUL
TO PEOPLE WHO MAKE
US HAPPY, THEY ARE
THE CHARMING
GARDENERS
WHO MAKE OUR SOULS
BLOSSOM.

Marcel Proust

LOVE IS THE ENERGY OF LIFE.

Robert Browning

GO CONFIDENTLY IN
LIVE THE LIFE

THE DIRECTION OF YOUR DREAMS,

YOU'VE IMAGINED.

Henry David Thoreau

THANK · YOU

To Julie Gibbs, Arielle Gamble, Jocelyn Hungerford and the extraordinary team at Lantern; to the Sussan Corporation, Australia, and the BCNA community — I am honored to work together with you.

To the **wisdom** of those past and present whose thoughtful words have inspired these illustrations: Thank you for encouraging me to live my life with **creativity, courage** and **passion.**

LANTERN

Published by the Penguin Group
Penguin Group (Australia)
707 Collins Street, Melbourne, VICTORIA 3008, Australia
(a division of Penguin Australia Group Pty Ltd)
Penguin Group (USA) Inc.
375 Hudson Street, New York, New York 10014, USA
Penguin Group (Canada)
90 Eglinton Avenue East, Suite 700, Toronto, Canada
ON M4P 2Y3 (a division of Penguin Canada Books Inc.)
Penguin Books Ltd
80 Strand, London WC2R 0RL England
Penguin Ireland
25 St Stephen's Green, Dublin 2, Ireland
(a division of Penguin Books Ltd)
Penguin Books India Pvt Ltd
11 Community Centre, Panchsheel Park, New Delhi
– 110 017, India
Penguin Group (NZ)
67 Apollo Drive, Rosedale, Auckland 0632, New Zealand
(a division of Penguin New Zealand Ltd)
Penguin Books (South Africa) (Pty) Ltd, Rosebank Office
Park, Block D, 181 Jan Smuts Avenue, Parktown North,
Johannesburg 2196, South Africa
Penguin (Beijing) Ltd
7F, Tower B, Jiaming Center, 27 East Third Ring Road North
Chaoyang District, Beijing 100020, China

Penguin Books Ltd, Registered Offices: 80 Strand,
London, WC2R 0RL, England

First Published by Penguin Group (Australia), 2013

10 9 8 7 6 5 4 3 2

Text copyright © Meredith Gaston 2013
Illustrations copyright © Meredith Gaston 2013

Design by Arielle Gamble © Penguin Group (Australia)
Illustrations by Meredith Gaston
Author photograph by Hannah Morgan
Colour reproduction by Splitting Image Colour Studio Pty Ltd,
Clayton, VICTORIA.
Printed and bound in China by 1010 Printing International Pty Ltd

National Library of Australia
Cataloguing-in-Publication data:

Gaston, Meredith, author, illustrator.
101 Moments of Joy and inspiration / Meredith Gaston,
writer and illustrator.
9781921383526 (hardback)
Quotations.
Quotations, English.
Inspiration – Quotations, maxims, etc.
808.882

penguin.com.au